CITYSKETCH
PARIS

A DOODLE BOOK FOR DREAMERS

CITYSKETCH
PARIS

NEARLY 100 CREATIVE PROMPTS FOR SKETCHING THE CITY OF LIGHTS

Illustrations by Melissa Wood

Text by Michelle Lo, Monica Meehan, Joanne Shurvell, and Melissa Wood

Race Point
PUBLISHING

I dedicate this book to:

NWI + HBI + CWI

My gifted map readers, my kooky road trippers,
my charming travel mates,
you've made our road, gladly traveled
a wondrous life.

Race Point
PUBLISHING

A division of Book Sales, Inc.
276 Fifth Avenue, Suite 206
New York, New York 10001

RACE POINT PUBLISHING and the distinctive Race Point
Publishing logo are trademarks of the Quayside Publishing Group.

Race Point Publishing © 2014

ISBN-13: 978-1-937994-38-9

Library of Congress Cataloging-in-Publication Data is available

Illustrations by: Melissa Wood
Text by: Michelle Lo, Monica Meehan, Joanne Shurvell, and Melissa Wood
Editorial Director: Jeannine Dillon
Designer: Jacqui Caulton

Printed in China

1 3 5 7 9 10 8 6 4 2

CONTENTS

HOW TO USE THIS BOOK

Big cities are full of promise. From the amazing art and architecture to the diverse food and culture, each city has its own unique collection of treasures to unearth. *CitySketch* is the perfect way to sketch the delights of your favorite urban retreat. Each page contains a fascinating anecdote as well as a creative prompt about a unique and lovable part of the city. On the opposite side of the page, a sketch is started for you. Then it's up to you to unleash your imagination to complete the sketch and add your own signature style to it. You can use *CitySketch* to practice sketching and doodling, to enhance your creativity, or simply to capture your favorite city on paper. So get out your pencil and start dreaming!

Architecture

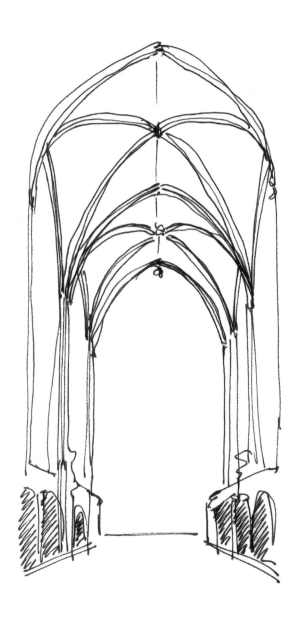

LA SAINTE-CHAPELLE (1248)

Located on the Île de la Cité, the gothic chapel La Sainte-Chapelle was built to house valuable Christian relics purchased by Louis IX. Interestingly, the holy treasures—including Christ's Crown of Thorns and a fragment of the "true cross"—cost three times as much as the chapel intended to showcase and safeguard them.

🖉 Gothic architecture was a strong departure from the wide-walled structural designs of previous construction models. Sketch the seven brilliantly colored panels in the chevet of the chapel.

île de la Cité

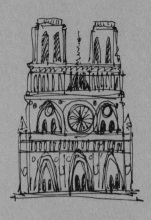

CATHÉDRALE NOTRE-DAME (1345)

Perhaps the best-known cathedral in the world, Notre-Dame is the anchor of the Île de la Cité, shaped to nestle permanently in the roost formed by the divided River Seine. Its gracefully thin walls are extremely light, but are supported by the protective, strong arms of the parade of flying buttresses. The first structure was conceived and built on such a monumental scale in Paris, that Notre-Dame took generations to construct, and it has gone through several renovations due in part to vandalism over the years, particularly in the 16th century. The delicate craftsmanship will likely continue to beckon the curious and the faithful for centuries to come.

✎ Complete this sketch of Notre-Dame, adding the delicate spire that was added to Notre-Dame well after the cathedral was first built.

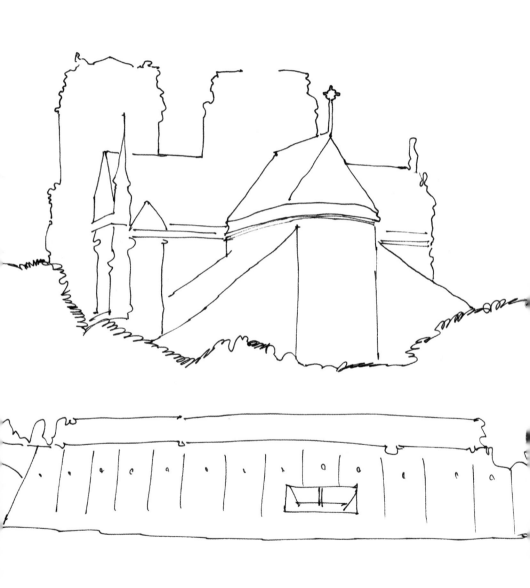

TOUR SAINT-JACQUES (1522)

Long after the Romans arrived with their ingenious method of draining the marshes that had been the landscape of the Left Bank, Paris was well on its way to spreading like a blanket far beyond the petite Île de la Cité. Churches were sprouting up, and the 4th arrondissement became home to the beautiful St. Jacques-la-Boucherie. Dedicated to the patron saint of butchers and located on the Rue de la Rivoli, the church was demolished during the French Revolution, leaving only this tower as a monument.

✎ The Tour Saint-Jacques is steps from the lively Les Halles. Finish sketching the tower in the midst of its busy neighborhood.

PONT-NEUF (1603)

As Paris stretched well beyond both sides of the River Seine, King Henry III was presented with a traffic flow problem. Earlier bridge designs had included rows of houses on them, but this new conception of a grand bridge, linking Rive Gauche, Rive Droite, and the Île de la Cité, would knock the socks off 17th-century Parisians. The first modern bridge in Paris boasting semi-circular terraced areas, pavements, and breathtaking views, Pont Neuf was also a hotspot for socializing and promenades.

✎ Complete this sketch by adding the Pont-Neuf and its twelve spectacular arches.

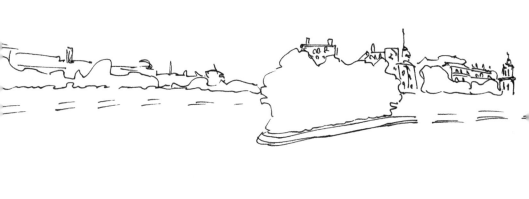
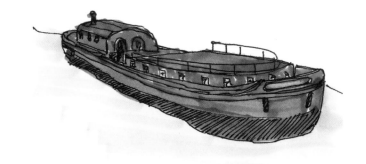

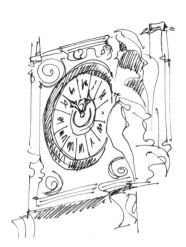

HÔTEL NATIONAL DES INVALIDES (1676)

Stretching along the bright green walk from the Eiffel Tower sits the massive Hôtel National des Invalides. Initially commissioned by Louis XIV as a hospital and retirement home for the French military, Les Invalides was designed to reflect the grand style that had come to represent Paris in all of its glory. Today, the building houses one of the world's largest war museums, but it's probably best known as the site of Napoleon Bonaparte's tomb.

✎ Sketch the impressive Dôme des Invalides (the Dome Church) rising above the view from the Seine.

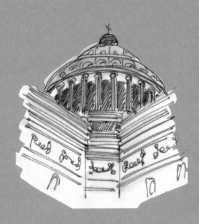

PANTHÉON (1791)

In 1744, a gravely ill Louis XV vowed to build a shrine to St. Genevieve should he survive. He recovered, and work began on what would later become known as the Panthéon.

After decades-long delays, marked by Louis's eventual death, the French Revolution, and several design changes, the final construction was completed in 1791. The building, a close facsimile of the famous Pantheon in Rome, includes classical facets of ancient design, such as Corinthian columns and a Greek cross floorplan. It now serves as the final—secular—resting place for many great men and women of France, including Victor Hugo, Voltaire, Jean Monnet, Pierre and Marie Curie, and Émile Zola.

✎ Complete this sketch of the interior of the Panthéon in Paris. Be sure to embellish it with the grandeur of its decor.

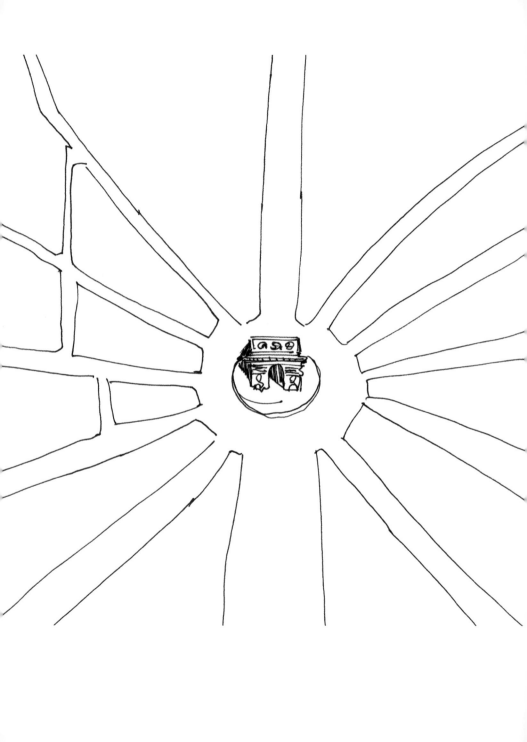

ARC DE TRIOMPHE (1836)

Intended by Napoleon to commemorate his victories at battle, the Arc de Triomphe serves as a great monument to his glory and is the capstone of a general redesign of the city in which the filthy and cramped medieval arrondissements were replaced with a gridded geometric system of wide streets and boulevards. The Arc de Triomphe—completed long after Napoleon was ousted from power—features reliefs of pivotal battles, 30 engraved shields bearing the names of major French military victories, and the lists of the names of more than 500 generals, among other features.

✎ Designed to mimic the shape of the star, the broad avenues on the left all lead to the Arc de Triomphe. Complete the sketch by adding the buildings that line these famous streets. Don't forget to include the inimitable terraces and french mansard roof details.

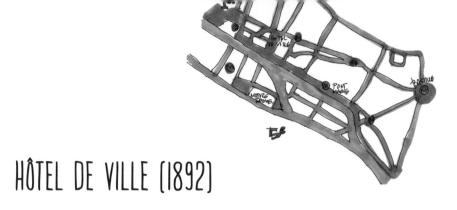

HÔTEL DE VILLE (1892)

Situated along the Seine, on what was earlier known as the Place de Grève, is the Hôtel de Ville, Paris's city hall. The present day Hôtel de Ville is actually a reconstruction; the original was burned in 1871. The new building was finished in an impressive 19 years, compared with the 30 years it had taken to build when it first opened in the 1850s. While it was once a site for public executions, especially during the French Revolution, today the guillotine has been replaced by a square, statues, and a public promenade.

Draw the impressive Hôtel de Ville as seen from a barge passing along the Seine.

BASILIQUE DU SACRÉ-COEUR (1919)

The jewel in Montmarte's crown, Sacré-Coeur was built with the intent to create an inspiring and morality-inducing Christian monument for the sprawling city below. Its presence helped shape the neighborhood—which had previously been farmland—into an artistic hotspot. Sacré-Coeur stands out for many reasons: its unusual Byzantine style, the prominent hilltop location, and the travertine stone in which it is clad—it secretes calcite when wet, naturally keeping the appearance of the basilica a pristine white.

🖉 Draw the famous Montmartre steps that lead Parisians back home from this beloved view.

TOUR EIFFEL (1889)

In 1889, to mark the centennial of the French Revolution, a World's Fair was held in Paris. For the event, bridge builder Gustav Eiffel designed a tower, which was initially intended to be a temporary structure. Each panel of iron was pre-fabricated and fit together in place, a technological marvel. Affording people a bird's eye view of the city for the first time, the tower forever imprinted on its visitors the beauty of the City of Light.

✎ Draw a detailed sketch of the intricate tower, noting the repetition of the simple geometric pattern that serves also as its structural support.

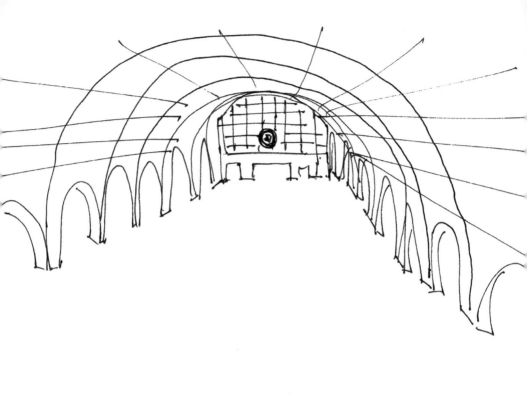

MUSÉE D'ORSAY (1900)

All aboard! Built initially as a grand train station to help service the flocks of travelers (Degas or Monet anyone?) in the great age of train travel, the building now known as the Musée d'Orsay is situated across the Seine from the Louvre. Opened in 1900, it was praised for its magnificent exterior façade as well as its iron-clad interior. Saved from demolition and restored in the late 1970s, it reopened in 1986 as an art museum, with a collection spanning from 1848 to 1914, including the masterpieces of French impressionism.

✎ Sketch the interior of the museum as it stands today—filled with paintings, sculptures, and art enthusiasts.

TOUR MONTPARNASSE (1973)

Architecturally speaking, Paris and the modern world had yet to meet until the 1970s, when President François Mitterrand envisioned a series of civic buildings and projects that would jettison the city into the 21st century. A stark contrast to the iron and cream-colored expanse of the majority of the French capital rose the Tour Montparnasse, a gleaming, sleek skyscraper that set the course toward the future, indeed.

✎ Sketch the Tour Montparnasse as it rises above the centuries-old neighbors.

CENTRE GEORGES POMPIDOU (1977)

The initial design for the Musée d'Orsay was rejected after an outcry from Parisians who thought it too industrial and structural; 77 years later when the Centres Georges Pompidou opened, Paris had evolved and embraced such an avant-garde proposal.

Outrageous, modern, and robust, the Centre Georges Pompidou was built seemingly devoid of its final skin, with its design, structure, and function all playing a part in the exterior design itself. And, as the pièce de résistance, the Centre appears as if it's clad in scaffolding. The building evokes assembly lines, factories, shipboard air ducts, and electrical circuits—all wrapped up into one iconic center for the arts.

✎ Function follows function in the 4th arrondissement. Complete this illustration of the CGP by adding the exterior-mounted staircase.

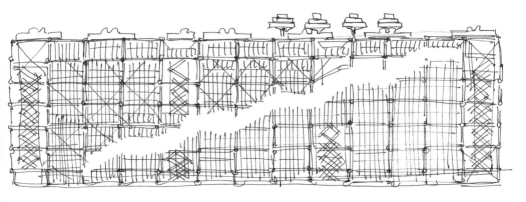

PYRAMIDE DU LOUVRE (1989)

By the 1970s, swelling crowds were making entry to the Louvre unmanageable. To fix the problem, President Mitterrand asked architect I. M. Pei to redesign public access to the museum. Amid cries of disdain, Pei built an all-glass pyramid, which not only created a subterranean entryway beneath the famous courtyard (thus solving the traffic-flow and crowd-control issues), but it also served as a beacon to visitors. Pei's pyramid is now of course one of Paris's most famous and recognizable structures.

✎ Add the pyramid to this sunset cityscape of the Louvre.

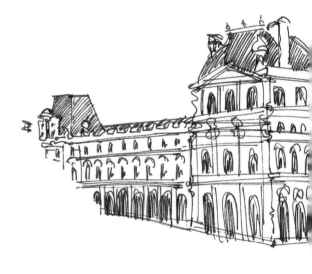

C_42 (2007)

Citroën and Paris go together like Chanel and style. What better way to solidify the city's love for this inimitable automaker than with a remarkable showroom? Built on the Champs-Élysées, where Citroën had once opened its first showroom in 1927, the C_42 is a high-tech road trip to both the past—and the future.

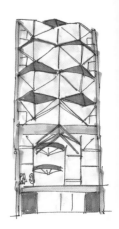

✎ Add a 1950-era Citroën to this revolving-turntable showroom.

Art

MUSÉE RODIN (RODIN MUSEUM)

The Musée Rodin (Rodin Museum), housed in an 18th-century mansion, contains the world's largest collection of sculptor Auguste Rodin's work. Wander the house and gardens and be inspired by the bronze and marble sculptures inside and out.

✎ Draw *Le Penseur* (*The Thinker*), the iconic bronze sculpture in the front garden of the museum. Note that while the male thinker looks lost in thought, his powerful body with its rippling muscles suggests he is ready for action.

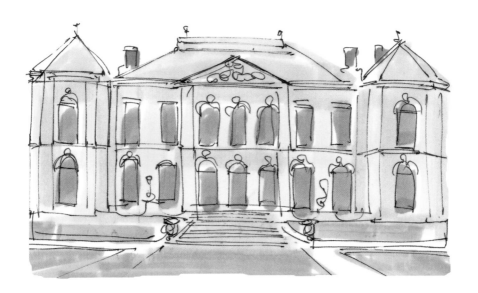

MUSÉE PICASSO (THE PICASSO MUSEUM)

Musée Picasso (The Picasso Museum), located in the Marais district, has a career-spanning collection of thousands of Pablo Picasso's paintings, drawings, sculptures, and ceramic works, along with his personal collection of other artists such as Seurat, Matisse, and Cezanne.

✏️ Draw the background and the head in the *Self Portrait* (1901) from Picasso's "blue period" when both the mood of his artwork and the paintings themselves were blue. Try to capture the somber, intense expression on the extremely pale face that is far too serious for a young man of only twenty.

MUSÉE DE L'ORANGERIE (ORANGERIE MUSEUM)

Musée de l'Orangerie (Orangerie Museum) in the Tuileries Gardens is best known for the two oval rooms featuring father of impressionism Claude Monet's eight large-scale *Nymphéas* (*Water Lilies*) paintings made in his garden at Giverny.

✎ Finish a side of one of the curved panels that show the white and pink water lilies in contrast with the blue and green of the water and surrounding vegetation.

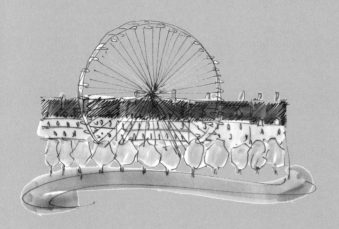

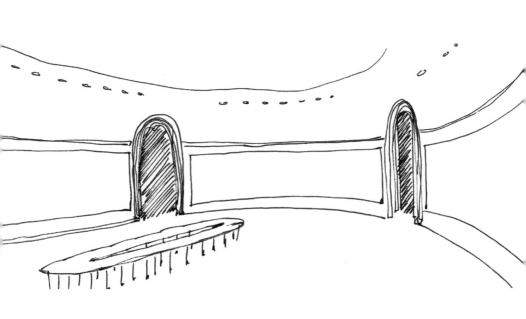

MUSÉE D'ORSAY (MUSEUM D'ORSAY)

Musée d'Orsay (Museum d'Orsay) is one of Paris's most popular art galleries, both for its stunning venue and for its outstanding collection of impressionist and post-impressionist paintings. Degas, Monet, Gauguin, and Van Gogh are all represented in the light, spacious rooms of this former train station.

✐ Sketch one of the sections of Pierre Bonnard's *Nannies' Promenade* (1897), a privacy screen that depicts mothers, children, and nannies strolling across the Place de la Concorde, along with a series of small horse-drawn carriages at the top of the screen.

THE STRAVINSKY FOUNTAIN

The Stravinsky Fountain in Place Stravinsky next to the Pompidou Centre is an homage to the composer Igor Stravinsky. This colorful piece of public art consists of 16 painted fiberglass and steel sculptures created by Jean Tinguely and Niki de Saint Phalle.

Draw the sculpture of the red lips and the black treble clef in the Stravinsky Fountain. Be sure to include the water and mist of the fountains to finish the piece.

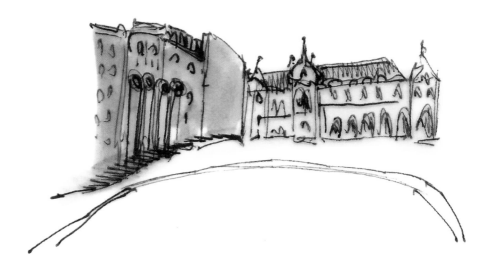

MUSÉE
D'ART
MODERNE
DE LA VILLE DE PARIS

MUSÉE D'ART MODERNE DE LA VILLE DE PARIS (THE MUSEUM OF MODERN ART OF THE CITY OF PARIS)

Located within the Palais de Tokyo, the Musée d'Art Moderne de la Ville de Paris includes modern art from the 20th and 21st centuries, ranging from Picasso and Matisse to Warhol and Basquiat.

✎ Italian artist Amedeo Modigliani's paintings are known for the elongated shapes he used for both people and objects. Draw the oblong face of Modigliani's *The Woman with Blue Eyes* (1918).

la viaduc de l'estaque 1908

THE GRAND PALAIS

Along with the adjacent Petit Palais, the Grand Palais was built for the Universal Exhibition in 1900. Today it houses national galleries and a science museum, while a police station in the basement protects the exhibits upstairs.

✎ Draw the simple geometric forms of George Braques's cubist masterpiece, *Le Viaduc de l'Estaque* (*Viaduct at l'Estaque*) (1908) in the Grand Palais.

THE PETIT PALAIS

Paris's fine art museum, the Petit Palais,
houses a major collection of artwork from ancient
Greece through World War I. The building itself has a
large number of colorful mosaics on the floors, fresco
painting on the ceilings, and decorative murals.

René Lalique was one of France's preeminent art nouveau jewelry
and glassware designers. Draw Lalique's *Pine Cone Bowl* (c. 1902),
a milky-white glass mounted into a silver metal frame decorated in
twisted grape vines.

MUSÉE CLUNY
(THE CLUNY MUSEUM)

Musée Cluny (The Cluny Museum) is a 15th-century
former abbey dedicated to the medieval period. It features
a stunning collection of medieval relics and tapestries.

✎ Finish drawing the unicorn in one the most famous pieces in the
collection, the expansive silk and wool tapestry called *The Lady and
the Unicorn*, made up of six panels. Note the sumptuous colors that
have remained intact to this day.

STREET ART

Paris, like most major cities, has a vast array of street art on walls, bridges, and buildings. The Belleville district is an excellent area to find colorful, vibrant graffiti, especially on Rue Dénoyez, a road where graffiti has been legalized.

🖋 Draw French street artist Fred Le Chevalier's well-known gothic couple on the walls of Rue Dénoyez. Be sure to accentuate their white, moon-like faces and black hair, and don't forget to add a touch of red in their clothing.

MUSÉE D'ART ET D'HISTOIRE DU JUDAÏSME (JEWISH MUSEUM OF ART AND HISTORY)

The Musee d'Art et d'Histoire du Judaïsme features art, textiles, and objects showcasing the history of Jewish communities in France and the rest of Europe.

✏️ Marc Chagall, described by art critic Robert Hughes as "the quintessential Jewish artist of the twentieth century," was also considered a pioneer of modernist avant-garde art. Draw Chagall's wife Bella in her red dress with its white frilly collar in his painting *Les Amoureux en Gris (Grey Lovers)* (1917).

RUE
Claude Monet

GIVERNY

Claude Monet's lovely house and gardens, Giverny, is open
to the public and located just 45 minutes by train from Paris.
Visitors can go to see the beautiful house where the father of
French impressionism lived for nearly half a century and stroll
through the beautiful gardens and ponds that inspired his
famous water lily paintings.

✐ Draw the green Japanese bridge covered with white, purple,
and pink wisteria over the pond of water lilies in the garden.

JEU DE PAUME

Jeu de Paume, on the Place de la Concorde, is renowned for its photography and video exhibitions. Paris was regarded as the photography center of Europe in the 1920s, and famous French photographers such as Henri Cartier-Bresson worked with Americans like Man Ray.

✎ Draw the silhouette of Man Ray's shadowy black-and-white photograph of the sculpture of Louis XV on his horse (1926) in the Place de la Concorde.

Culture

PALAIS GARNIER

Completed in 1875, Paris's premier opera house can seat nearly 2,000 music lovers. It has also become famous as the setting for the fictional and hugely popular *Phantom of the Opera*. Its beautiful restaurant, L'Opéra, is popular with famous divas and other notable patrons.

✎ Sketch the opera's ceiling by artist Marc Chagall, one of the masterpieces of the opera's beautiful interior. Draw it from the position of sitting in one of the plush seats and looking up, with the chandelier in the center and the sparkling lights surrounding the rim.

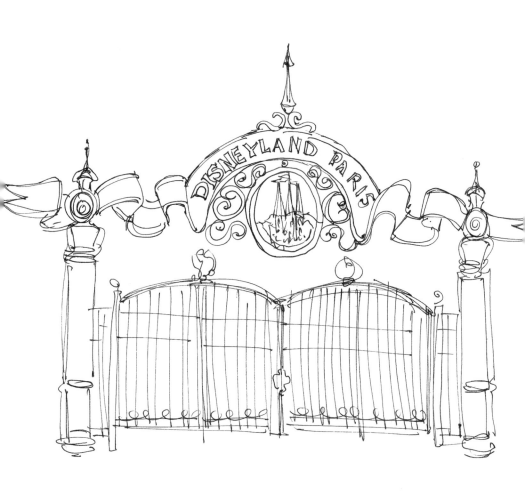

DISNEYLAND PARIS

Europe's very own Mickey and Minnie reside in the suburbs of Paris and are visited by millions each year, who can choose from over 50 rides and attractions. From the Mad Hatter's Tea Cups to Pirates of the Caribbean, the magic of Disney has something to offer for all ages.

✎ Complete the sketch on the left by drawing your favorite Disney characters with the famous Sleeping Beauty Castle as a backdrop. Make it a night scene with lots of fireworks and some of Disney's beloved characters who flutter through a magical night of celebration.

SHAKESPEARE AND COMPANY

Paris is for book lovers, and this well-loved shop first opened its doors in 1919 near the shores of the city's Left Bank. Although it closed during the German occupation, a second Shakespeare and Company opened in the 1950s and remains as a bookstore, reading library, and temporary home for travelers who, in exchange for a bed, work a few shifts on the shop floor.

✎ Sketch a few students sitting in the bookshop surrounded by stacks of beautiful books. One is reading an ornately designed hardcover art book while another is thumbing through the pages of a well-worn paperback.

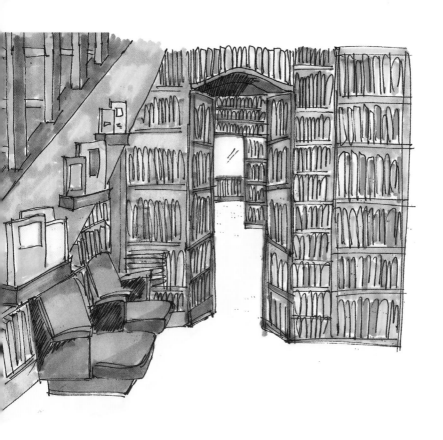

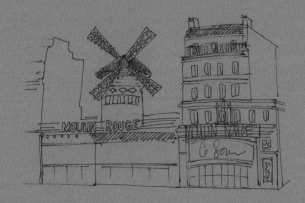

LE MOULIN ROUGE

In the heart of the Pigalle district sits Paris's most famous cabaret, Le Moulin Rouge. Marked by a bright red windmill on its roof, it first opened its doors in 1889, and soon thereafter the world was introduced to the modern form of the can-can dance.

✎ Complete the sketch on the left by drawing can-can dancers on the stage like you might remember from the famous Toulouse-Lautrec paintings with big skirts and plumed headdresses. Draw the Moulin Rouge sign and the famed windmill above the sketch.

INDIE CINEMA AT LA PAGODE

The French are passionate about film, especially independent cinema. Designed by a French architect, La Pagode is a 19th-century replica of a glorious pagoda. Some says it's one of the most beautiful cinemas in the world. Countless independent films have played here since 1931.

✎ Draw the interior of La Pagode with a couple watching a classic movie on the big screen, surrounded by paintings, tapestries, and lampshades on the walls. Leave some space to doodle a bit of the façade of the building, an elegant replica of a 19th-century Japanese pagoda temple.

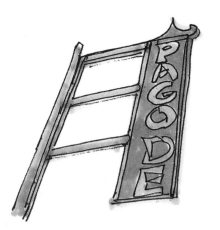

LET'S PLAY BOULES!

Boules is a classic French game involving throwing or rolling heavy balls on a level rectangular court. It's typically played outdoors on a warm afternoon or summer evening. Two favorite spots to play in Paris are the Jardin du Luxembourg or Les Arènes de Lutèce, home of the first Roman amphitheatre.

✎ Draw a boules court with an intense game being played in this amphitheater. Include local Parisians gathering to play and standing around the scattered boules. Add a few men sitting and resting as well.

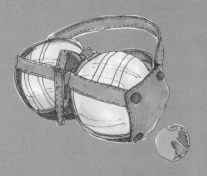

FESTIVAL MONDIAL DU CIRQUE DE DOMAIN (WORLD FESTIVAL OF THE CIRCUS OF TOMORROW)

This yearly festival gathers together the world's most talented young circus performers and acrobats in competition for a place at Cirque du Soleil. Over a long weekend in January, you can pay to see tightrope walkers, clowns, jugglers, and trapeze artists strut their stuff in the most exciting and daring acts imaginable.

✎ Fill a circus tent with all kinds of performers, from tightrope walkers to trapeze artists. They should be wearing extravagant costumes and attempting daring feats. Don't forget to draw a few clowns at the base of the stage cheering on their fellow artists.

PARIS JAZZ FESTIVAL

You know summer in Paris has arrived when the sound of jazz fills the air. From funk, soul, hot, cool, swing, and every jazz style in between, the city hits the high notes every July for a two-week musical feast for the ears. Jazz clubs and outdoor venues take part to celebrate new and established talent during the Paris Jazz Festival.

✎ Draw a poster for the upcoming Paris Jazz Festival using your favorite font. Add a saxophone player, an iconic image of Paris such as the Eiffel Tower or Arc de Triomphe. Like the music itself, make the sketch moody and atmospheric.

LA NUIT DES MUSÉES (MUSEUM NIGHT)

For one night in spring, all Paris museums open for free from around 7 P.M.–1 A.M., making the whole city feel like an open-air museum. There is an excitement in the air knowing you can appreciate Degas at dusk or the *Mona Lisa* at midnight.

✎ Sketch a self portrait of yourself among the dinosaurs at the National Museum of Natural History (Le Muséum National d'Histoire Naturelle), adding the shadows of T. Rex torsos and big open mouths against the backdrop of several large windows with a half moon shining through.

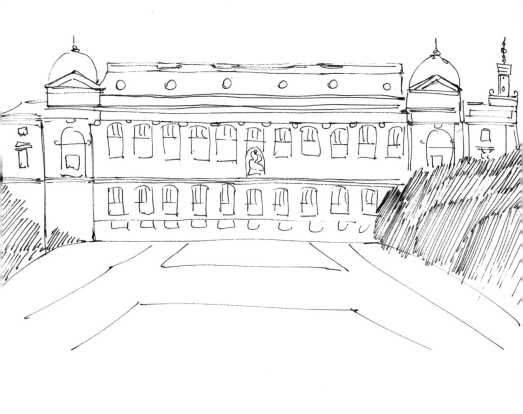

LA FÊTE DE LA MUSIQUE

LA FÊTE DE LA MUSIQUE

La Fête de la Musique is a lively street music festival held every June 21st in Paris and is one of the year's most popular events. Hundreds of musicians gather in the streets, bars, and cafés, giving free performances of everything from jazz and rock to hip-hop and electronic music.

✎ Draw a lively street scene with musicians playing on the banks of the river Seine. Make it a big party, as everyone is invited!

L'AQUARIUM DE PARIS (CINÉAQUA)

The aquarium, which is located just across the Seine from the Eiffel Tower, is home to many exotic fish, and of course, a shark tunnel. There are also cinema-like spaces in front of giant glass tanks where you can comfortably sit and watch the fascinating creatures of the sea.

✎ Draw all kinds of colorful fish, big and small, around the sketch of the aquarium on the right. Include a baby shark, flora, plants, and coral.

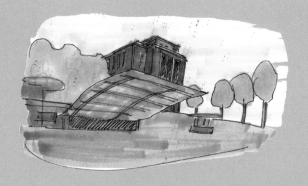

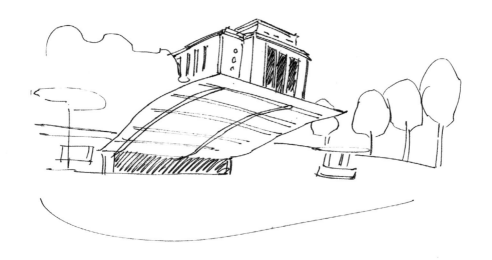

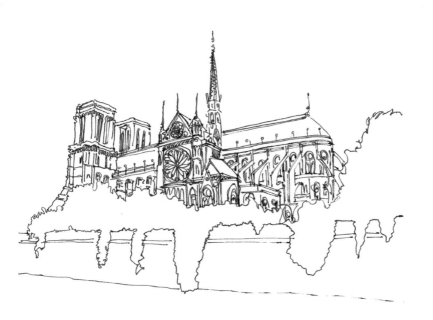

MUSIC IN NOTRE-DAME DE PARIS CATHEDRAL

Music has played a major role in the Notre-Dame cathedral since the 12th century. Weekly and monthly organ recitals and concerts bring splendor to the many church services. The choirs, organists, choirmasters, and the cantor maintain the cathedral's history through heavenly sounding music, which is mesmerizing to visitors who come from the world over.

✎ Draw the outline of a large choir standing near the great organ inside the church. Add a beautiful stained glass window behind them.

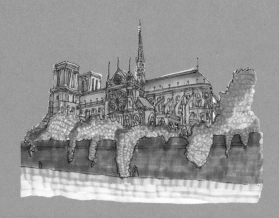

BROCANTES AND FLEA MARKETS

Browse for books or bric-a-brac, bag a bargain, or rummage for vintage clothes and shoes in a gem of a *brocante* (second-hand shop). The number of permanent and weekly markets specializing in food, art and antiques, flea market items, and collectibles is vast, and there's nothing more enjoyable than a quiet morning searching for a hidden treasure.

✎ Sketch a flea-market scene as you would imagine it, including some items you might like to purchase for a few Euros. Add an old doll rescued from a Parisian attic, some rustic dishes, albums from yesterday's French singing stars, old postcards of seaside towns, or a few vintage pairs of shoes or handbags. Let your imagination soar!

Fashion

CARINE ROITFELD

Model, stylist, journalist, muse, and former editor of *Vogue Paris*, Carine Roitfeld sits at the helm (or maybe *hem*?) of the fashion world. She broke taboos by celebrating elegance and beauty in sexuality and is often heralded as the ultimate *femme Parisienne*.

🖊 Famed for her work with photographer Mario Testino, Carine Roitfeld has a signature style: figure-hugging pencil skirts, black leather, and cinched waist toppers. Dress the models in the photo shoot with her unique look.

COLETTE

Paris's one-stop concept and lifestyle store was first conceived in the late 1990s as a showcase for all things hip and cool. More than a decade later, it continues to feature an incredible collection of covetable goods—from must-have accessories and luxury apparel to exclusive sneakers and home furnishings.

✎ Sketch the façade of the famous Colette boutique with mannequins sporting your favorite Parisian fashions and accessories.

APC

Less is more when it comes to
Jean Touitou's fashion label, Atelier
de Production et de Création. As the go-to
destination for the effortlessly chic (and cool), APC is renowned
for pared-down basics and a no-fuss approach to fashion. Relaxed
cardis, cotton A-line dresses, and well-tailored peacoats would
not look out of line.

✐ Create a wall display of minimalist staples in their flagship shop.
This can include a Breton-striped sweater paired with their legendary
jeans. Or a smocked dress and ankle boots.

VINTAGE

There's little more rewarding than going on vacation and returning with that one special vintage find, which you snatched up for pennies at an unknown *friperie* (the French term for second-hand shops). Kiliwatch, Omaya Vintage, Frip'irium, and By Flowers are just a few of our favorites.

For vintage haute couture, Didier Ludot is the go-to spot for in-the-know fashionistas. Finish the window display by decorating the models in some of the boutique's finest garb.

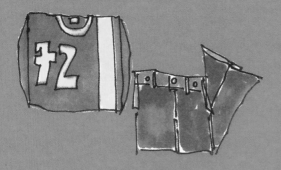

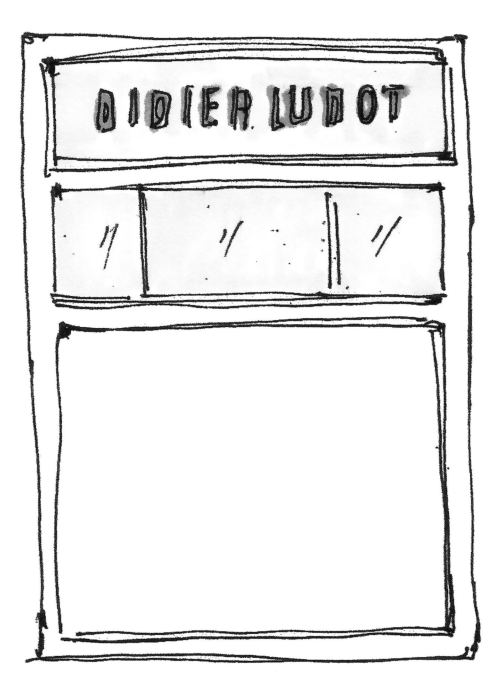

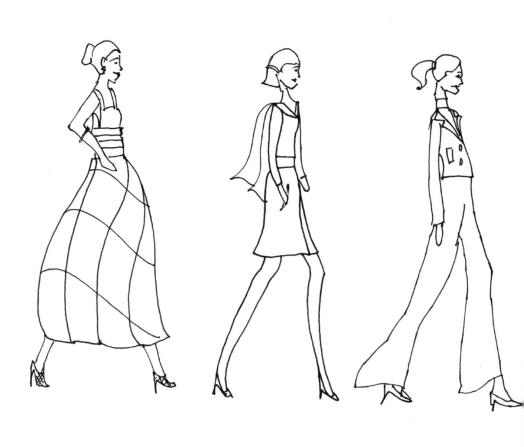

CHRISTIAN DIOR

J'adore Dior. As the Western world's most influential fashion designer during the late 1940s and 1950s, Christian Dior reigned over the fashion world with tailored, hourglass silhouettes. Since then, the fashion house has expanded as a brand to include a range of products ranging from sunglasses and accessories to perfume and makeup.

✎ Accessorize these three runway silhouettes with signature Dior looks including hats, gloves, jewelry, and heels.

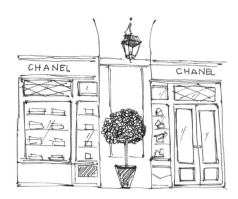

CHANEL

Parisian designer Gabrielle "Coco" Chanel once said, "A girl should be two things: classy and fabulous." Her designs inspired women to replace their restrictive petticoats and corsets with elegant silhouettes for the modern lifestyle. Fast forward eighty years later with Karl Lagerfeld at the helm of design, and Chanel has expanded into the quintessential luxury brand.

✎ The Chanel handbag is one of the most instantly recognizable designs in fashion history. Draw the classic quilted handbag with the woven leather chain and logo.

KARL LAGERFELD

A long snow-white mane, black sunglasses, and highly starched collared shirts ... you know who we're talking about. As head designer and creative director of Chanel, Fendi, and his eponymous label, the Paris-based fashion veteran, artist, and photographer Karl Lagerfeld is one of the most instantly recognizable faces of fashion.

✎ He once made an offhanded comment that he would marry his cat, Choupette, if it were legal. Draw Karl and Choupette in a happy place sitting among long-legged models wearing his legendary designs.

MUSÉE DES ARTS DÉCORATIFS (MUSEUM OF DECORATIVE ARTS)

For a more cultured approached to fashion, the Musée des Arts Décoratifs is a must-see on any fashion itinerary. Boasting a permanent collection of more than 16,000 costumes and 35,000 accessories, the museum rotates the displays in temporary exhibitions due to the fragile nature of the pieces. This could range from a collection of avant-garde designers to the history of fashion through the modern age.

✎ Create an exhibition worth visiting by sketching a collection of conceptual design. Perhaps you prefer the haute couture of Lanvin or Christian Lacroix? Or maybe Commes des Garçons or Martin Margiela?

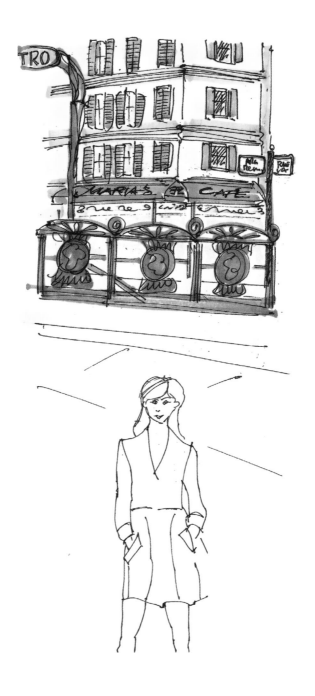

THE CHERRY BLOSSOM GIRL

Trés chic! Alix Bancourt, better known as the Cherry Blossom Girl, started her fashion career as an intern for Chloé and Alexander McQueen before becoming the doyenne of Parisian fashion blogging. Flirty, playful, and feminine, her personal style is quintessentially French, quirky, and thoroughly modern.

✏ A little Sonia Rykiel here, a little high street there . . . If there ever were a wardrobe to be had, hers would be it. Finish this drawing of the CBG dressed for a night on the town. Red lips, a statement handbag, and heels would not go amiss.

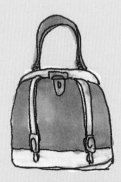

PARIS FASHION WEEK

This semiannual event brings the top names of fashion together to report, forecast, and dictate key trends for the upcoming season. Though there are three other key fashion weeks—New York, London, and Milan—the Parisian event is renowned for showcasing the finest in haute couture.

✎ A big fashion house certainly needs an environment as over-the-top and elaborate as the fashion they're showing. Create a lavish and impressive show that will leave attendees in awe—with a crowd this discerning, it's worth pulling out all the stops.

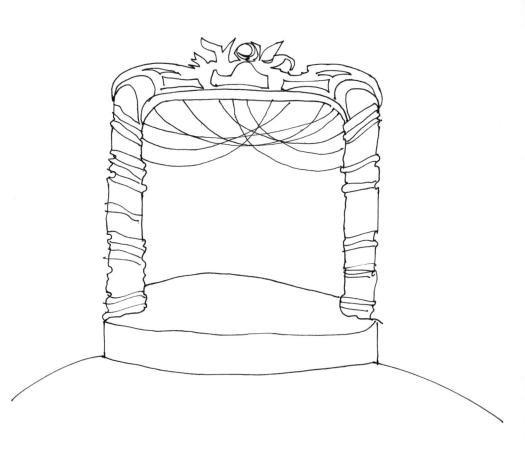

BALLET FLATS

In recent years, ballet flats have become a ubiquitous footwear trend among fashionistas, their mothers, grandmothers, and everyone in between. Paired with jeans and T-shirt or a tea dress, this understated wardrobe staple is designed to work for most occasions without compromising style or comfort. And if there was a be-all and end-all in the world of ballet slippers, Repetto is the name to note.

Rose Repetto created her first ballet shoes in her workshop on the Rue de la Paix, and ever since, clients such as Brigitte Bardot and Kate Moss have fallen head over heels—so to speak. Sketch a pair of classic Repetto ballet flats below in your favorite pattern. Add in your own creative touches.

HERMÉS SCARF

Did you know that every 25 seconds, an Hermés scarf is sold somewhere in the world? It's an impressive, if not unsurprising fact. Since 1937, the scarf has been produced in over 2,000 patterns by nearly 150 artists—and as one of fashion's most coveted accessories, it has the power to add elegance and luxury to a simple outfit.

✏️ Each scarf is screen-printed individually on silk, which may explain its price tag. Whether tribal, geometric, or graffiti, create a truly original scarf that's both ornate in design and reflective of your own personal taste.

TRENCH COAT

The classic beige trench may be one of the greatest wardrobe staples of the century. Tailored, functional, and stylish, a *"Le Mac"* is a superb investment because it can add instant chic to an outfit, whether paired with old jeans or a cocktail dress. In fact, it is an essential to the closet of every elegant French woman.

✎ As with your lipstick and phone, you should never leave home or travel without your trench coat. You decide what the model wears with it and feel free to embellish with custom details, but do it sparingly— it is a classic after all.

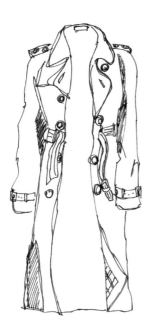
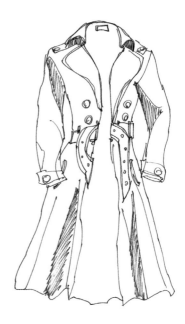

Food

BAGUETTES

Nothing symbolizes French food culture quite like the classic baguette. Traditional baguettes are between 24 to 30 inches long and are baked in steam-producing ovens, which delay crust formation so the loaves can fully rise. Sold in French bakeries known as *boulangeries*, they have a major presence throughout the country.

✎ Decorate the shelves of a local boulangerie with some of the favorites: baguettes, round country loaves, bread with poppy seeds, and sandwich loaves.

CROISSANTS

There are few better places to eat in the world than in France, a country where butter is practically its own food group. The perfect croissant should have a lightly glossed shell filled with sheet-thin layers of deliciousness and finish with a sweet, salty buttery note.

🖉 Create the perfect Parisian breakfast setting with a basket of freshly made croissants, coffee, and a newspaper.

MACARONS

Over the years, the historic Ladurée brand has been synonymous with macarons—that dainty, meringue-based sandwich cookie — and has become known as much for its pretty packaging as it is for the delicate confectioneries. The signature raspberry flavor could end wars, while quirkier options such as caramel with salted butter keep things interesting. A guilty pleasure if there ever was one.

✎ Finish sketching the elegant macaron shop on the right. Add in customers sampling a few delectable and colorful treats. In the space above, draw your own personal box of macarons including both classic and modern flavors. Be inspired by Pâtissier Pierre Hermés whose concoctions are famous for being unconventional, radical, and delicious. Foie gras and chocolate, anyone?

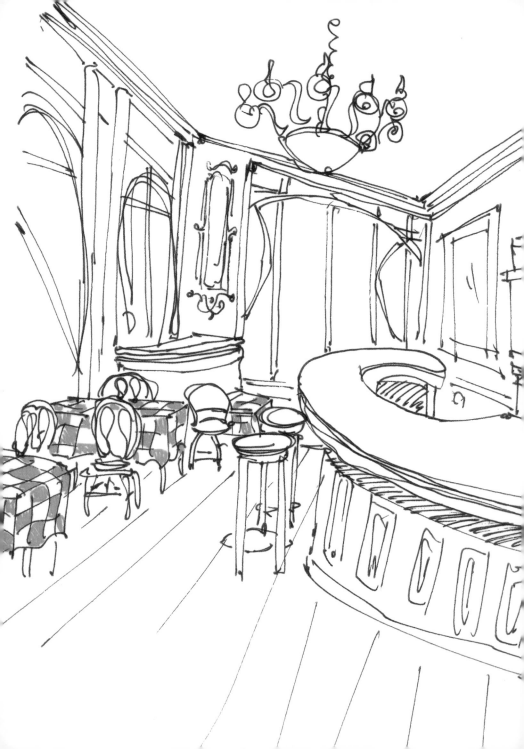

FRENCH BISTRO

If you're craving traditional French cuisine, look no further than the classic bistro, where you can experience favorites like *coq au vin* and *tarte tatin*. The dim-lit setting, the checkered tablecloths, and wooden chairs are comfortingly old-fashioned and romantic all in the same breath.

✎ Locals and tourists flock to the "neo-bistro" Le Chateaubriand, one of the most sought-out Parisian foodie destinations. Try creating artful presentations of some of Le Chateaubriand's dishes such as "Velvet Crab Bouillon" or "Veal, Pear and Brown Butter."

CRÊPES

Visitors gravitate to the City of Light for its food as much as for its culture. Crêpes, single-handedly the best street food in Paris, appeal to all walks of life. Sweet or savory, the super-thin pancake can be filled with ham and cheese, Nutella® and banana, or simply butter and sugar.

Sketch your favorite crêpe combination below. Perhaps something sweet like a lemon, butter, and sugar crêpe? Or a strawberry chocolate crêpe with a touch of cream?

STEAK FRITES

Vegetarians, bypass this page. When properly
cooked, the steak bursts with flavor and
satisfies all the cravings for French comfort
food. Traditionally speaking, the meat should be *saignant* (rare),
the fries light and crisp, and the béarnaise sauce well rounded.

✏ Prepare this classic dish: Add grill marks to the steak, sketch
a mound of thin-cut fries, and serve with a classic French sauce—
béarnaise, bordelaise, au poivre, or maître d'hôtel butter—or create
your own.

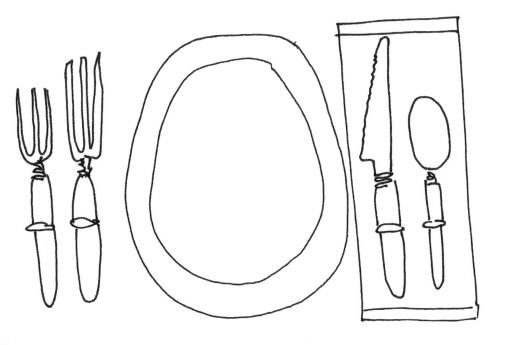

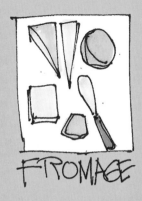

FROMAGE

CHEESE

The French serve their cheese after the main meal to aid digestion. With more than 400 different French cheeses available, the basic cheese board should include four types: a hard cheese (Comté), a flowery cheese (Brie or Camembert), a blue cheese, and a goat cheese.

When the sun shines, nothing beats a picnic by the Seine. Sketch the scene to include your favorite picnic dishes and French cheese, which could include Brie de Meaux, Camembert, chèvre, or Roquefort. Include a bottle of your favorite wine for a winning combination.

CHOCOLATES

In Paris, the finest cocoa-based delicacies come to life, and the artistry of the chocolatier shines through. Truffles are presented as works of art, slabs of chocolate can be festooned with glorious patchworks of fruits and nuts, and chocolate-rich ganaches make euphoric treats.

✎ Finish drawing in this beautiful chocolate gift box, showcasing some of the best artisanal chocolates on offer. The box should be as beautiful as the chocolates themselves.

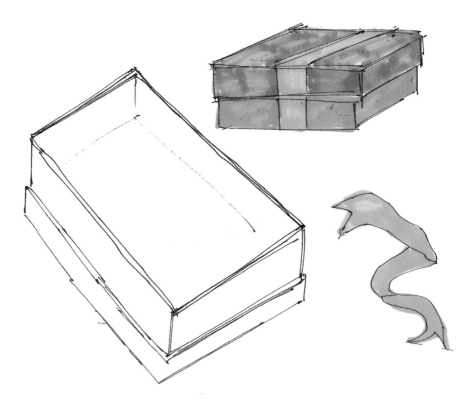

BAR À VINS

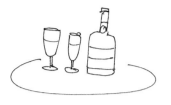

Wine bars are plentiful in the world but nothing quite compares to the convivial spirit of a good *bar à vins* which has the feel of classic Paris. Oenophiles head to these time-honored wine bars to enjoy a quality vintage, saucissons, and fromages.

✎ The ideal menu should have an extensive collection of wines à la carte and cheese and charcuterie boards. The wines have already been selected, so it's up to you to complete the boards of charcuterie and cheeses.

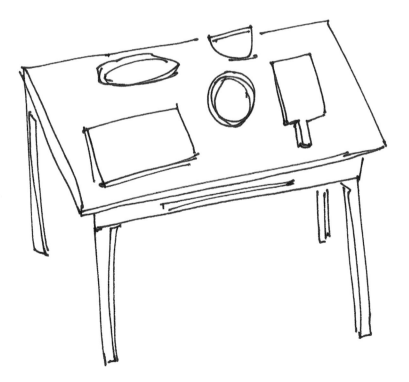

ICE CREAM

Summer is synonymous with ice cream, and in Paris the artisanal ice cream will leave you content, refreshed, and pleasantly satisfied. From the classic flavors at Pozzetto to caramel ice cream with pink Himalayan salt and *cioccolato fondente* at Grom, ice cream lovers are spoiled for choice . . .

Berthillon houses arguably the best ice cream in the city— if not the world. Fill the cones with your favorite ice cream and sorbet flavors.

HOT CHOCOLATE

When the mercury drops, ward off the chill with a cup of hot chocolate. Rich, intense, and velvety, traditional Parisian hot chocolate is a perennial treat: Die-hard foodies flock to Café de Flore for a steaming cup, and adventurists head to Jean-Paul Hévin to sample the eyebrow-raising hot chocolate with oysters, iodized foam, and jelly balls.

✐ Sketch a jug of intensely rich hot chocolate, served with a side of whipped cream and cookies.

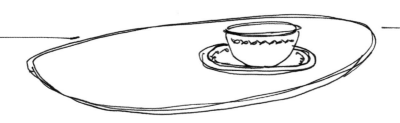

JOËL ROBUCHON

Widely acclaimed as one of the world's best chefs, this grandmaster of French cookery boasts 28 Michelin stars and owns more than 20 restaurants worldwide. Signature dishes include his potato purée (renowned for the 2:1 potato to butter ratio) and a free-range quail stuffed with foie gras.

✎ When dining at his atelier, one can expect the best in French gastronomic cuisine. Reinterpret some of his signature recipes or other unconventional dishes, such as the mint mousse with pea and asparagus or the apple jelly, Granny Smith sorbet, and sweet cider emulsion.

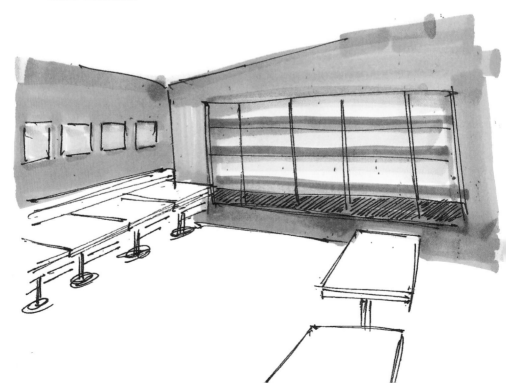

LAFAYETTE GOURMET

From Jean-Paul Hévin chocolates to Mariage Frères tea, some of Paris's best and most luxurious food shops are represented in this expansive food emporium. Galeries Lafayette Gourmet stocks thousands of products and also includes concessions from popular restaurants and brands.

✎ Sketch a freestanding kiosk in Lafayette Gourmet with artisanal charcuterie. This could include legs of cured ham and sausages and a broad selection of terrines and pâtés.

ORGANIC MARKET

Situated at Boulevard Raspail, Paris's first organic market—
Marché Biologique Raspail—is the one-stop foodie destination
for fresh produce such as heirloom tomatoes, fresh chèvre,
fragrant herbs, raw chocolate, and roasted chickens. It's open
every Sunday from 9 A.M.–1:30 P.M., but go early to avoid the
crowds—or late to grab a bargain.

✎ At this upscale market, you'll find certified organic eggs, cheese,
honey, and fruits. Finish drawing this produce stall with boxes of fresh
lettuce, herbs, tomatoes, and berries.

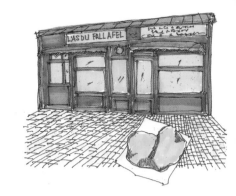

FALAFEL

The Jewish section of town is located at the renowned Rue des Rosiers. For a fiver, you'll find budget-friendly falafel sandwiches served in a pita, topped with vegetables, and finished with fresh hummus. L'As du Fallafel's version is a meal in itself while Mi-Va-Mi's tops its rendition of the crispy chickpea fritters with roasted vegetables and a mild tomato salsa.

✎ You've waited patiently in line for this authentic and delicious snack. Fill your falafel pita with the chickpeas and veg, and top it off with hummus and specks of paprika.

Landscapes

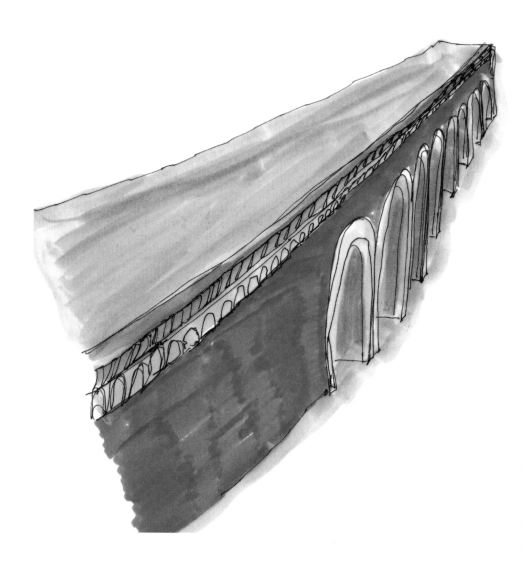

LA PROMENADE PLANTÉE (TREE-LINED WALKWAY)

The inspiration for New York City's High Line, this three-mile long elevated pedestrian pathway atop a nineteenth-century railway viaduct opened in 1993 and starts at Place de la Bastille.

✏️ Draw a view of the wooden walkway passing under a red rose trellis, with a large planter of flowers in the middle and a green wooden bench on one side.

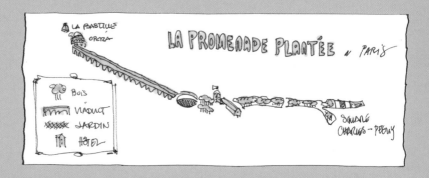

JARDIN DES TUILERIES

The Tuileries Garden near the banks of the river Seine between the Louvre and the Place de la Concorde, has been a fashionable place to stroll since it opened in the 16th century. Made on the site of a former tile factory (*tuilerie*) for Louis XIV, the garden was opened to the public after the French Revolution.

✎ Draw the octagonal pond in the center of the park along with a few visitors reclining on the green metal chairs at the water's edge while reading and relaxing.

JARDIN DES TUILERIES

⚜ VINCENNES ⚜

BOIS DE VINCENNES (VINCENNES WOODS)

On the eastern edge of Paris, Vincennes Woods is the largest public park in the city. Created for Emperor Louis Napoleon between 1855–1866, it features four artificial lakes, botanical gardens, a zoo, and Château de Vincennes, a medieval castle that was the former residence of the kings of France.

✎ Finish the view of the Château with its vast grounds by drawing the lawns leading up to and including the Château's famous donjon tower, the tallest medieval structure in Europe where the Marquis de Sade was once imprisoned.

BOIS DE BOULOGNE (BOULOGNE WOODS)

On the western side of Paris in the 16th arrondissement, Boulogne Woods is a sprawling forested park that was a former hunting ground of the kings of France and is now home to the annual French Open tennis tournament. Parisians wanting to escape the hustle and bustle of city life flock to this park's lakes, wooded paths, and gardens.

Le Jardin de Bagatelle (Garden of Bagatelle) in the Bois de Boulogne is famous for its 9,000 rose bushes and its iris garden. Finish one of the delicate pink rose bushes beside the triangular topiary trees with the green rolling lawns and woods in the background.

PRIÈRE
DE NE PAS
MARCHER
SUR LES
PELOUSES

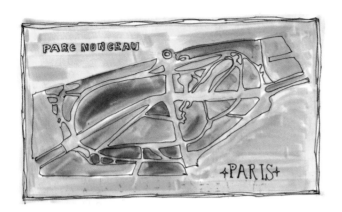

PARC MONCEAU

A public park in Paris's 8th arrondissement, Parc Monceau is English rather than French in style with its informal curved design and randomly placed sculptures and statues.

✏ Be inspired by Claude Monet, who painted several paintings in this park, including *The Parc Monceau* (1878), on view at the Metropolitan Museum of Art in New York. Draw a couple cycling on one of the curved paths past an older lady sitting on a bench beside a beautiful pink magnolia tree.

PÈRE LACHAISE CEMETERY

Supposedly the world's most visited cemetery
due to a number of famous gravestones like
The Doors' singer Jim Morrison, writers
Honoré de Balzac, Marcel Proust, Gertrude
Stein, and Oscar Wilde, and musicians Maria Callas,
Frédéric Chopin, and Édith Piaf— Père Lachaise Cemetery
is a massive 100 acres.

✎ Sketch the winding cobblestone path hemmed on each side by
large-leafed chestnut trees that lead up to Chopin's tombstone, which
is covered in fresh flowers.

PARC DES BUTTES-CHAUMONT

Parc des Buttes-Chaumont in the 19th
arrondissement is a public park in northeast
Paris featuring a grotto, waterfalls, and an artificial lake with
a suspension bridge designed by Gustave Eiffel, the architect
behind the Eiffel Tower.

✎ Draw the rocky island at the center of the park's lake. Be sure
to include Temple de la Sibylle, a miniature white Roman temple,
emerging from the top of the rocks.

PLACE DES VOSGES

The picturesque Place des Vosges, located in the Marais district, is the oldest square in Paris, dating back to the 17th century. Unusually for the time, all the houses on the square were built in the same redbrick design over vaulted arcades; they now house expensive shops.

✎ Draw one section of the arcades looking out onto the square with its trees and formal garden in the center.

MARAIS

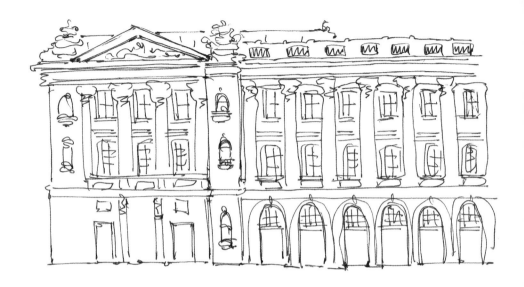

HÔTEL DE CRILLON

It was in the Hôtel de Crillon in the Place de la Concorde
that the Treaty of Alliance was signed in 1778 by the French
and American governments, marking the defensive alliance
of the two countries during the American Revolutionary War.
While today's visitors to the Place de la Concorde enjoy the
fountains and the Egyptian obelisk, during the 18th century,
this public square—the largest in Europe—was the site where
Marie Antoinette and Louis XVI were guillotined.

🖉 Draw a group of tourists entering the Hôtel de Crillon on the
left of the fountain in the square. Include the French flag flying from
the roof of the building.

AVENUE FOCH

The widest street and most expensive address in Paris, Avenue Foch is lined with chestnut trees and grand houses belonging to both the Rothschild and the Onassis families.

✎ Sketch the expansive avenue starting at the Arc de Triomphe. Include the trees lining each side as well as the outlines of several typical French cars, such as a Citroën and a Renault.

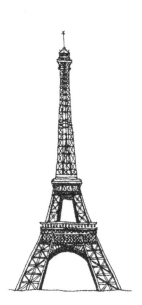

THE EIFFEL TOWER

The iconic Eiffel Tower provides the ideal vantage point for views across Paris. Since its opening in 1889, visitors have been climbing it, making it the most visited monument in the world.

✎ Sketch the urban landscape of Paris from the top of the Eiffel Tower, taking in the astonishing views of rooftops and gardens that stretch for 40 miles.

CHÂTEAU DE VERSAILLSES (PALACE OF VERSAILLES)

A 45-minute train ride from Paris will bring you to the grand palace and gardens of Versailles, the residence of the kings of France until the French Revolution in 1789. One of the most spectacular landscapes of France, it's well worth the trip.

✎ Draw a view of the palace from across the Bassin de Neptune (Basin of Neptune), including the sculpture of the Roman god of the sea, Neptune, in the foreground.

JARDIN DES PLANTES

Jardin des Plantes, the most important botanical garden in France, contains over 10,000 species within its magnificent greenhouses and outdoor gardens. It's the perfect retreat from the cars and crowds in the Paris streets.

🖊 Finish drawing a section of the formal garden in Paris with the hedges on either side of the straight paved paths. Include the lion sculpture in the center.

CANAL SAINT-MARTIN

With its locks and metal bridges, Canal Saint-Martin was built in the 19th century to provide a shipping link between the Seine and northern Paris.

✎ Draw a metal bridge over the canal leading to one of the many cafés and bars that line each side of the canal. Include a Parisian couple sitting outside at one of the tables listening to a jazz saxophonist performing nearby.

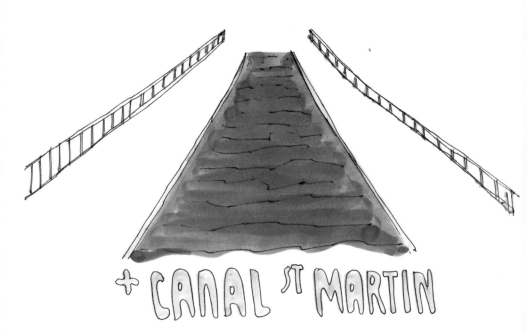

People-Watching

CAFÉ LIFE: LES DEUX MAGOTS AND CAFÉ DE FLORE

Cafés and Paris go together like croissants and coffee. Two of the most famous cafés in Paris, Les Deux Magots and Café de Flore, were the homes-away-from-home for Hemingway and his talented posse of fellow artists in 1920s Paris. The intelligentsia would spend long afternoons and evenings over a single cup of coffee before moving on to a starry and boozy Paris night. Today, the cafés remain crowded—and are a crucial element of Parisian life.

✎ Sketch the busy café life at Les Deux Magots. Include patrons at a few tables with closed umbrellas as well as a Gallic-looking waiter in black bow tie and tails and an ankle-length white apron. His one arm is suspended in the air, carefully balancing a tray of café au lait and a piece of cake.

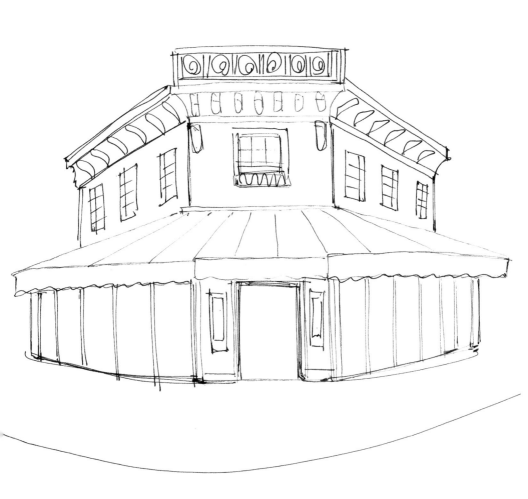

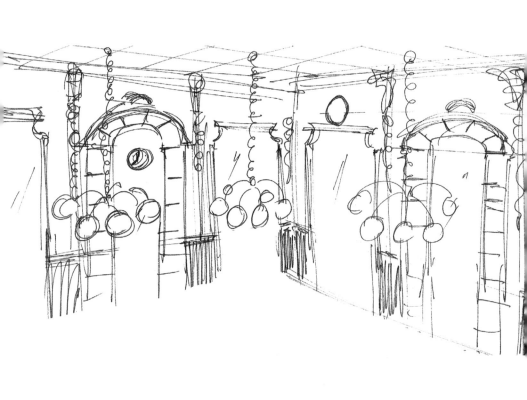

LA MAISON ANGELINA
(ANGELINA'S TEA ROOM AND CAFÉ)

Angelina's is a must-see when visiting Paris. Popular with both tourists and locals alike, it is a chocolatier, tea room, grand dining salon, and great people-watching spot. It has been said that Proust, Coco Chanel, and Audrey Hepburn have all passed through its doors, just minutes away from the Louvre. Back then, Angelina's may not yet have offered its famous African hot chocolate, served on a silver tray with a generous dish of whipped cream on the side, but certainly Coco and Audrey would have sipped its delicious tea and perhaps even indulged in a Mont Blanc.

✎ Angelina's is always, always full. Complete the crowded dining room scene on the left by adding a family of tourists dining, a waitress rushing past, and many other diners enjoying afternoon tea and dessert. Add the famous hot chocolate and remember to mark every piece of china with a pretty Angelina signature on its side. Remember that the room is opulent and add paintings and beautiful light fixtures to the sketch.

SUNBATHERS ALONG THE SEINE

For those who can't escape to the French Riviera, let the Riviera
come to Paris! The city has created a "Paris Beach along the
Seine" for city-dwellers in need of sun and sand during the hot
summer months. Complete with recycled sand, palm trees, and
a view of the sea (well, the river at least), this makeshift beach
is a great way to spend your weekends outside while still being
just minutes away from city life.

✎ Sketch sunbathers on the concrete banks of the Seine. Add sand,
palm trees, striped beach umbrellas, and beach huts. Draw one of
Paris's beautiful arched bridges in the background.

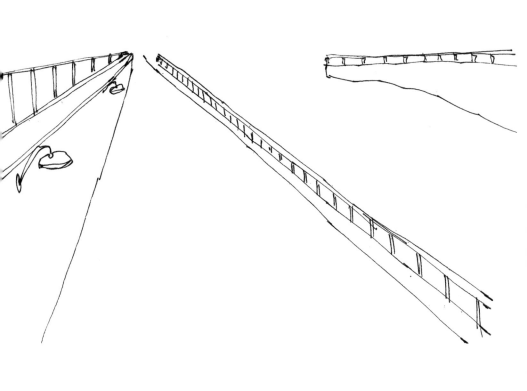

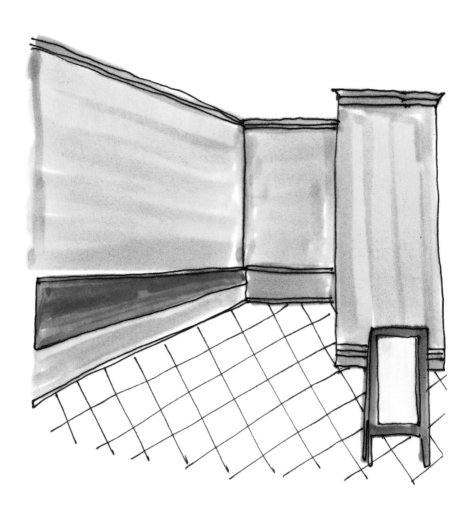

BISTRO

LE BISTRO: THE FRENCH BISTRO

The white linen tablecloths, the small bistro tables with a candle glowing on each, the wall-to-wall paintings and photographs adorning the centuries-old walls, and a chalkboard menu outlining the day's delicious specials. This scene makes you want to spend a lazy afternoon in a French bistro, sipping red wine after a wonderful three-course meal with your favourite lunch companion.

🖉 Complete the sketch on the left by drawing yourself and a friend in a typical French bistro, enjoying a bottle of wine over a leisurely lunch. Draw the interior as it is described above. Make sure to scribble a few delicacies on the chalkboard and add a wooden bar with big mirrors behind it and rows of wine bottles.

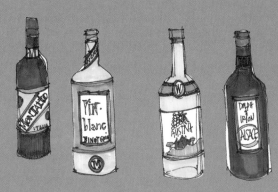

STUDENTS AT THE SORBONNE

The University of Paris-Sorbonne is one of the oldest universities in the world, dating back to the 13th century. The original complex of the Sorbonne still sits on its medieval foundations and has been extended into the Latin Quarter. The Sorbonne specializes in the arts and social sciences, and over 23,000 students are lucky enough to study at the prestigious institution with the motto: *Here and anywhere on earth.*

✎ Sketch students in the university's main courtyard, imagining them engaged in a philosophical debate. In the background add the beautiful fountain and a French national flag gently swaying from one of the age-old buildings.

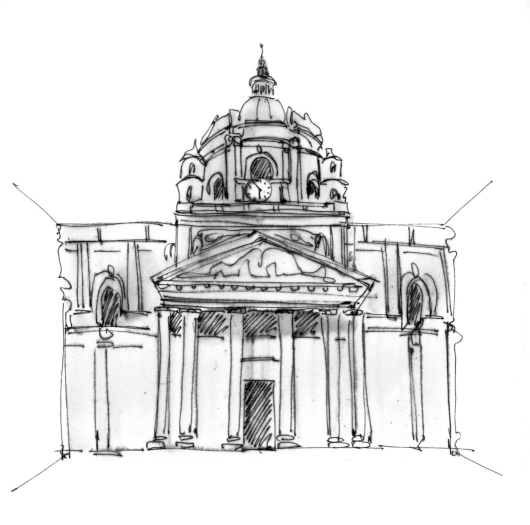

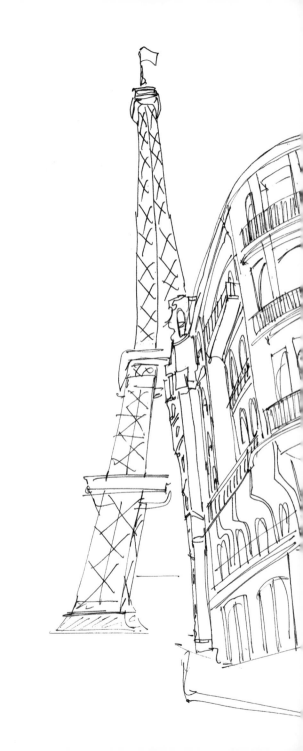

CLOWNS AND STREET PERFORMERS

The French love their clowns and street performers, and you'll often encounter a few on a lively Paris street. Crowds gather round to see a clown, a gold statue who comes alive with a wink or hand gesture, or a dance troupe performing acrobat-like moves. If there's musical accompaniment as well, a few locals may grab a partner and join in.

✎ Draw performers on stilts wearing period costumes and moving above the onlookers who raise their heads in awe. Add a few saxophone players to create a bustling scene. Perhaps there's a festival in town, and a clown with big shoes, curly hair, and heavy makeup is waiting his turn to wow the crowds next.

DINING WITH DOGS: PET-FRIENDLY PARISIAN RESTAURANTS

The French love their pooches, as is evident in the many dog-friendly restaurants scattered throughout Paris. Indoor dining is more suitable for little dogs, but at outdoor cafés, dogs of different shapes and sizes sit happily at the feet of their masters, patiently waiting for a delicious morsel to drop from the table.

✎ Sketch the outdoor terrace of a French restaurant. One ice cream parlour allows dogs on its terrace, so have a little fun and let the mutt sit on its own chair next to you with its very own scoop of ice cream.

WINDOW SHOPPERS

French shops have a unique charm, and Paris boutiques in particular have a very special quality. Whether they sell soaps and fine linens or antiques and books, these shops offer plenty of tempting luxuries to lure you in off the cobbled streets of the inner city. If you can't quite afford the pricier items, you can at least admire them through the glass!

✏ Complete the sketch of an elegant French couple browsing outside a chic Parisian shop. Perhaps it's a beautiful shoe shop with classic and expensive-looking designer shoes and handbags. Sketch a pretty façade and sign above the shop, giving it a very French name such as Chez Madeleine.

MARKET VENDORS

Paris is filled with delectable markets featuring local and out-of-town vendors who organize their goods for the public to admire and try, and, of course, buy. From seasonal fruit and vegetables to meats and cheese, locals gather to buy fresh food on a regular basis. The purveyors of these stands are often as colorful as the produce or wine they are selling!

✎ Doodle a vendor behind his cheese stall. Have him extending his arm and offering a piece of cheese to a customer, who is obviously enjoying the sample. Include other shoppers in the scene, with their wicker baskets filling up with food on a sunny morning.

CYCLISTS IN THE CITY

After *le métro* (the subway), Parisians' most popular mode of transport is *le bicycle*. You can rent one from the hugely popular Vélib', an affordable city-run bike-sharing service that allows you to pick up a bicycle from one destination and drop it off at another. It helps keep the city green—and its inhabitants in top shape.

✎ Sketch a woman on a Vélib' below, with the front basket filled with groceries, including a baguette peeking out of the top. As this is Paris, show her wearing a pretty, striped sundress and small scarf around her neck or on her head. She'll be riding along a lovely tree-lined street with a well-known landmark like the Arc de Triomphe in the distance.

JARDIN DU LUXEMBOURG (LUXEMBOURG GARDENS)

On a sunny day, Parisians head to the city's second largest public park, the Jardin du Luxembourg, for a day of people-watching, reading the papers, or simply soaking up the rays. At the center of the park is an octagonal pond known as the Grand Bassin where children can rent small sailboats. There are also many other attractions for children such as a merry-go-round, puppet theater, and pony rides.

✏ Complete the sketch below by showing children playing by the water, tugging sailboats while their patents look on. As it is a sunny day, add little boater hats on the kids. You may wish to include a family of ducks and their ducklings waddling past.

LE MARAIS

LE MARAIS/JEWISH QUARTER

The Marais is a historic district of Paris and also its most famous Jewish quarter, home to Jewish families off and on since the 13th century. Like many neighborhoods in Paris, the area has adapted to modern times, and its streets are now lined with gay bars, falafel shops, and cafés plus a mix of stylish boutiques, galleries, and vintage treasure troves. The main street, Rue des Rosiers, which means "street of the rosebushes," still boasts Jewish delis and bakeries with an old-world feel.

✎ Complete the sketch by drawing people waiting outside a Jewish deli, perhaps the famous Sacha Finkelsztajn, with its bright yellow storefront and window display of delectable goodies. Add the narrow cobbled roads and street lamps to illustrate the busy main thoroughfare of the Marais.

ARTISTS IN MONTMARTRE

Situated on a hill high above the center of Paris, Montmartre has long been home to many aspiring and legendary artists. Geniuses like Vincent van Gogh, Edward Degas, and Pierre-Auguste Renoir worked in Montmartre and drew some of their inspiration from the area. While it's a little more commercial these days, promising artists still come here to paint and to sell their reasonably priced works to the many visitors.

✎ Complete the outline of an artist sketching a caricature with the sitter—you!—patiently waiting to see the masterpiece. Have the artist dressed in typical bohemian style, complete with a painter's cap. Surround the sketch with easels and palettes of paint and other works of art, which could include landscapes, portraits, and still life.

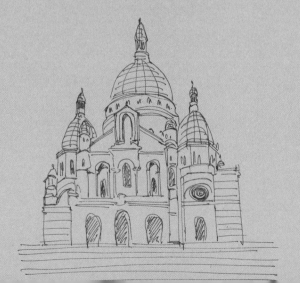

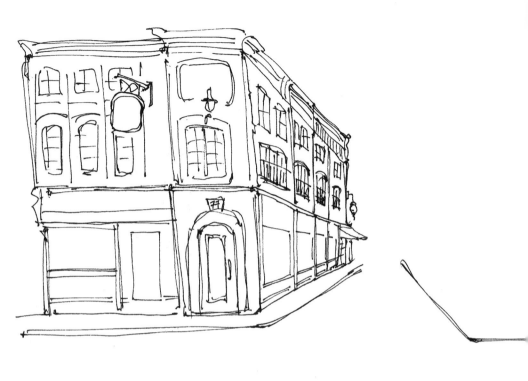

PARIS GLAMOUR GIRLS

Paris is world-famous for being the birthplace of haute couture and ready-to-wear fashion. Parisian women have an enviable reputation for dressing with casual elegance and looking effortlessly stylish, slim, and impeccably groomed at any age— from a trendy school girl to a grand dame in ballet flats, a well-tailored coat, and handmade leather gloves.

✎ Sketch a fashionable young woman in a tree-lined street scene as if she were posing for a photograph. You can add a Metro sign for the subway. It often rains in Paris so have her holding a beautiful umbrella, careful not to get her high-heeled boots or perfectly tousled mane wet.

ABOUT THE AUTHORS

MELISSA WOOD is both an illustrator and writer. Her permanent case of wanderlust, coupled with her addiction to history and lifelong love of travel is how the *Citysketch* series was born. She lives and works in the country, a stone's throw from the energy of Chicago. She has three witty children, two poorly behaved dogs, and one fluffy cat.

MICHELLE LO studied at the Fashion Institute of Technology and The New School University. After working as an editor, she obtained a chef-training degree and has since worked on numerous cookery books by leading chefs, such as René Redzepi and Ferran Adrià. Michelle is currently a freelance writer and editor and devotes her life to the pursuit of food and style with her photographer husband and young daughter.

MONICA MEEHAN is a freelance writer and author of *The Viennese Kitchen: Tante Hertha's Book of Family Recipes*. She also works in publishing and divides her time between New York and London. Monica is an avid traveler, cook, people-watcher, and Francophile.

JOANNE SHURVELL is an award-winning travel and arts writer. She is also the owner of PayneShurvell, a contemporary art gallery in London.